SuperVisions
ACTION OPTICAL ILLUSIONS

Al Seckel

Sterling Publishing Co., Inc.
New York

Book Design: Lucy Wilner
Editor and Layout: Rodman Pilgrim Neumann

Library of Congress Cataloging-in-Publication Data
Seckel, Al.
 Action optical illusions / Al Seckel.
 p. cm. -- (Super visions)
 Includes index.
 ISBN 1-4027-1828-4
 1. Optical illusions--Juvenile literature. I. Title. II. Series.
 QP495.S429 2005
 152.14'8--dc22

 2004019481

10 9 8 7 6 5 4 3 2 1

Published by Sterling Publishing Co., Inc.
387 Park Avenue South, New York, NY 10016
© 2005 by Al Seckel
Distributed in Canada by Sterling Publishing
ᶜ/o Canadian Manda Group, 165 Dufferin Street
Toronto, Ontario, Canada M6K 3H6
Distributed in Great Britain by Chrysalis Books Group PLC
The Chrysalis Building, Bramley Road, London W10 6SP, England
Distributed in Australia by Capricorn Link (Australia) Pty. Ltd.
P.O. Box 704, Windsor, NSW 2756, Australia

Printed in China
All rights reserved

Sterling ISBN 1-4027-1828-4

For information about custom editions, special sales, premium and
corporate purchases, please contact Sterling Special Sales
Department at 800-805-5489 or specialsales@sterlingpub.com.

CONTENTS

INTRODUCTION

Prepare to be utterly amazed and dumbstruck, because inside this volume, you will find many of the world's most powerful optical illusions—images that have illusions relating to brightness, color, and subjective motion. In fact, these illusions are SO powerful, you will have a very hard time believing the difference between what your mind knows and what it perceives. In most cases, you will not be able to stop yourself from being tricked, even though you fully know that you are being tricked! This is why it is so important for you to read the captions with each image, because you will not know that you are being tricked until you read what the effect actually is! But that is what is so fun about this book. In some cases, it will help to have some paper handy to make peepholes to compare different areas, which appear remarkably different in context, but are actually the same when isolated and compared. Many of the images in this volume are brand new and have not been previously published.

The illusions in this book have been grouped into the categories: Illusions of Relative Motion; Illusions of Brightness and Contrast; Color Illusions; and Afterimages and Aftereffects.

Although in some sense, all the illusions in this book are puzzlers, they are not an intelligence test. These illusions are all meant to be fun! Share them with your friends and watch how they won't believe their own eyes.

—Al Seckel

ILLUSIONS OF RELATIVE MOTION

Some of these illusions will convey motion when there is no motion. In other cases, you will make the image move, but your perception of its motion is different from what you normally expect from experience.

The Pinna-Brelstaff Revolving Circles Illusion

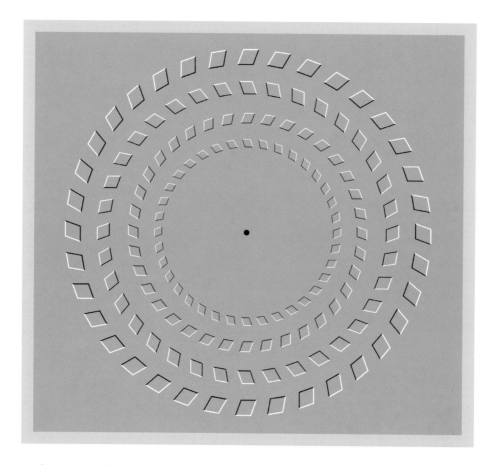

Stare at the center of the image and slowly move your head towards the page, and then away from it. The circles should counter-rotate. When you move your head away from the page, both motions reverse direction, reversing the direction of the illusion.

Leviant's Enigma

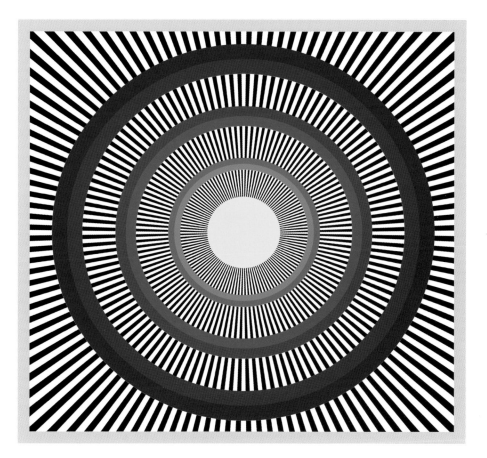

If you stare at the yellow circle, you will perceive a white swirling motion within the rings. If you stare at it long enough, the streams will reverse direction.

Pinna's Deforming Square Illusion

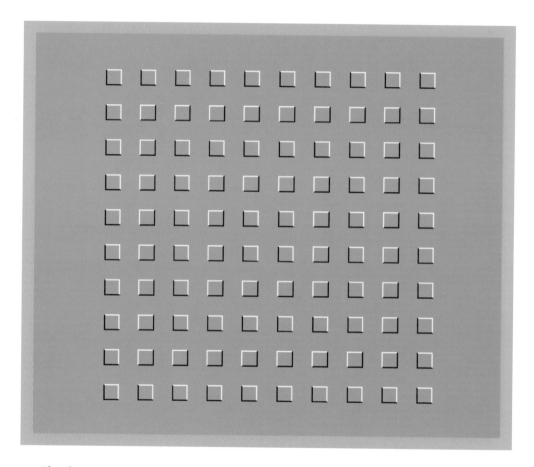

Slowly move this image in an irregular manner and the perfect squares will appear to deform.

Kitaoka's Spa Illusion

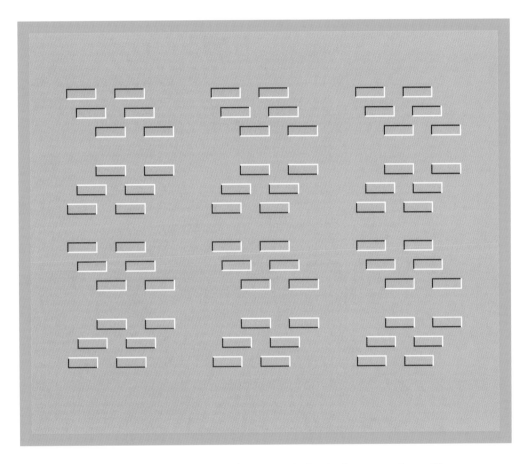

Slowly move this image up and down, and the little rectangles will appear to move with respect to each other.

MacKay's Figure of Eight Illusion

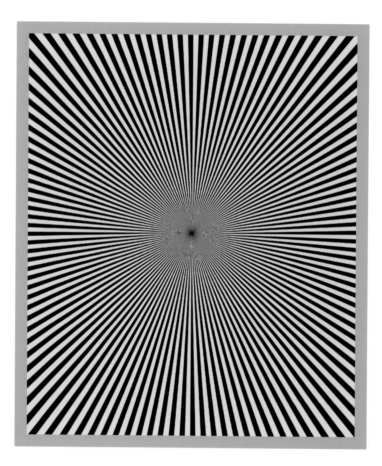

Move this figure either right or left and you will perceive blurred "figures of eight" moving perpendicular to the true direction of motion. If you stare steadily at the center you should see a rotation pattern. You can get the direction of rotation to change by fixating on a point left or right of the center of the image.

Pinna's Separating Squares Illusion

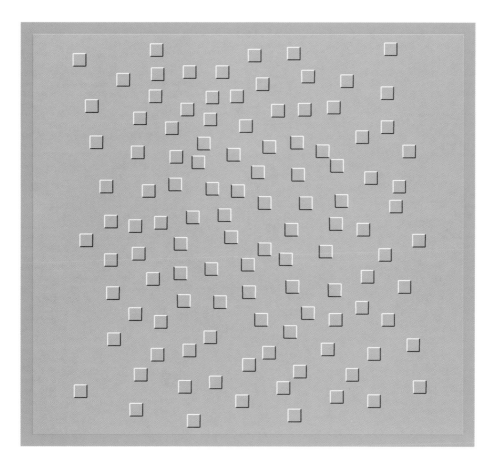

*If you move your eyes across this image or slowly shake the image, the
center squares will appear to separate in depth and
move in a slightly different manner than the surrounding squares.*

Flip-Flop

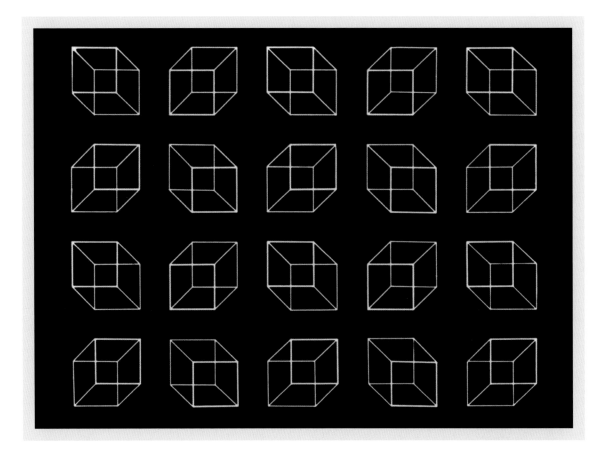

If you steadily stare at all the cubes, they will all suddenly flip-flop in orientation.

The Ouchi Illusion

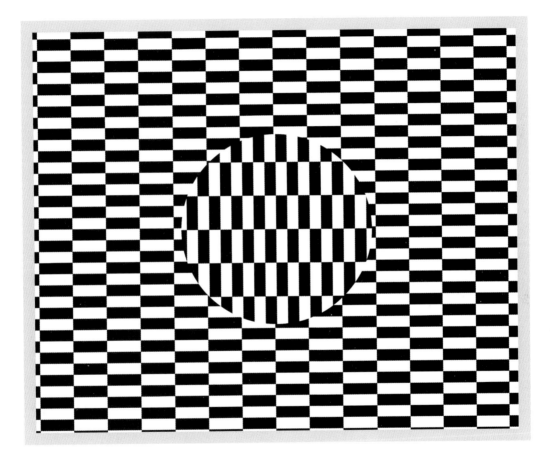

*If you move your eyes across this image or slowly shake the image,
the center section will appear to separate in depth and move slightly
in a direction opposite to its surround.*

Hula-Hoop Illusion

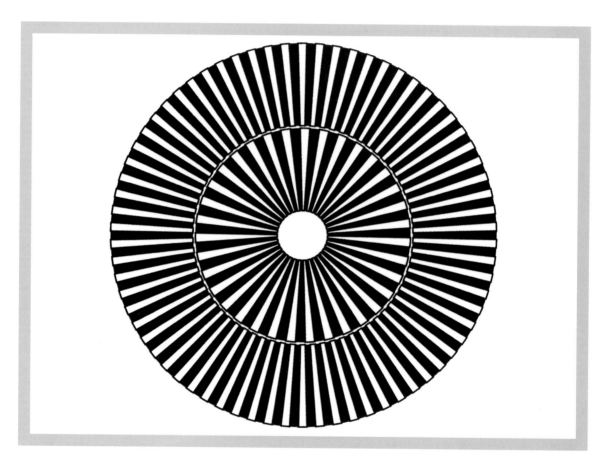

View this image while moving it quickly in a circular fashion without changing its orientation. The motion should be similar to how you rinse a cup. You should see the intermediate circle move along with this movement, like a hoop being spun slowly around the hips.

Morellet's Tiret Illusion

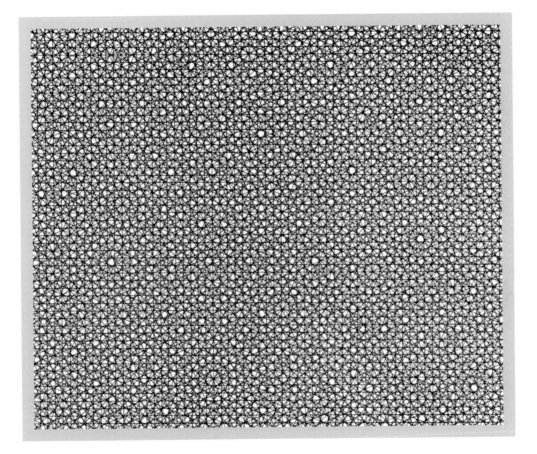

Move your eyes around this image and small the circles will appear
to scintillate and fade.

Reginald Neal's Square of Three

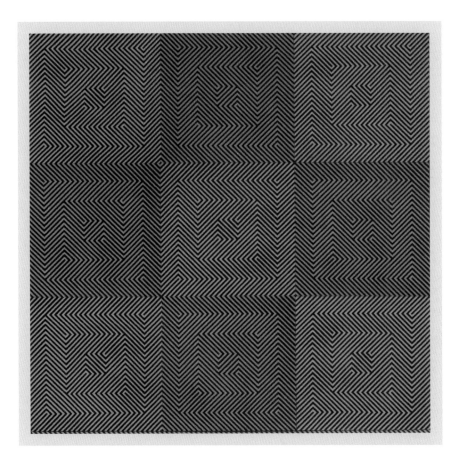

This pattern appears to pulse and ripple as you move your eyes across it.

Vibration 1

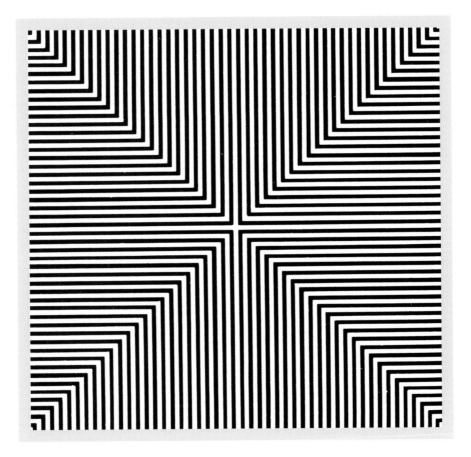

Slowly shake this figure and it will appear to vibrate.

The Concentric Circles Illusion

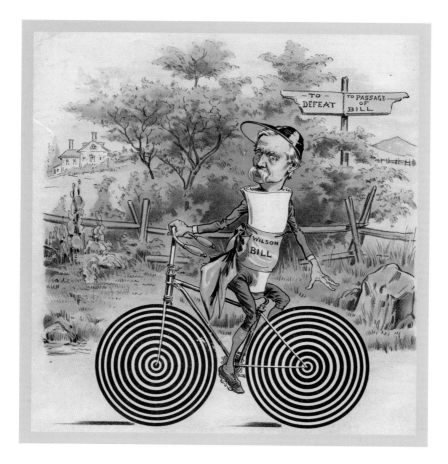

Move this image in a circular fashion and the bicycle wheel spokes will appear to turn.

Pinna's Splitting Lines Illusion

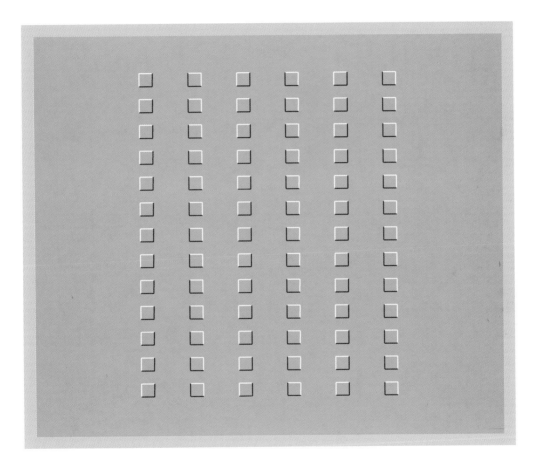

Slowly move this page up and down and the lines will appear to separate.

Illusionary Profits

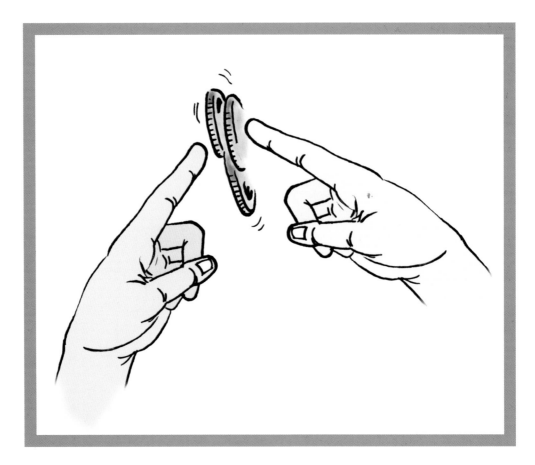

*Take two quarters and rub them together quickly,
and you will perceive a third coin.*

The Traffic Illusion

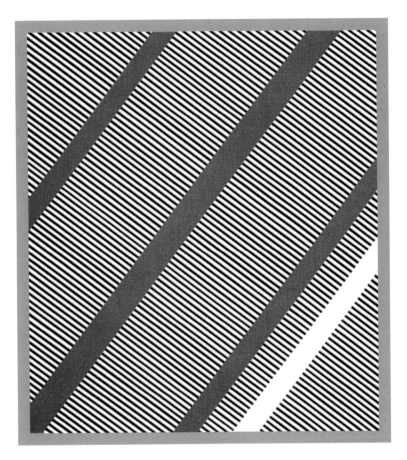

If you stare at this image, you will perceive some motion in the stripes.

Hidden Illusion

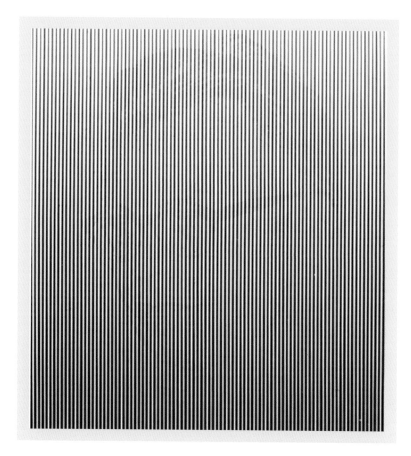

Slowly shake this image, and you will see a man's face.

Shimmer

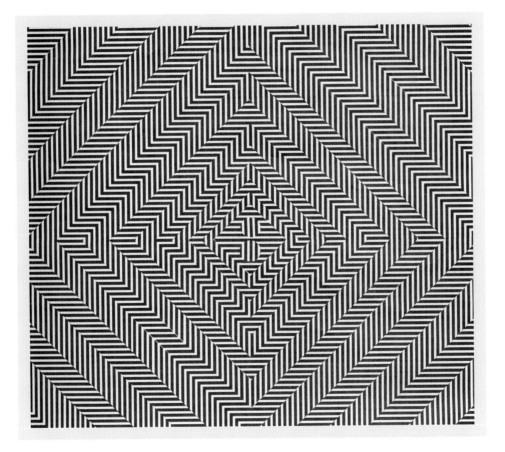

If you stare at this image it will appear to shimmer.

An Unbalanced World

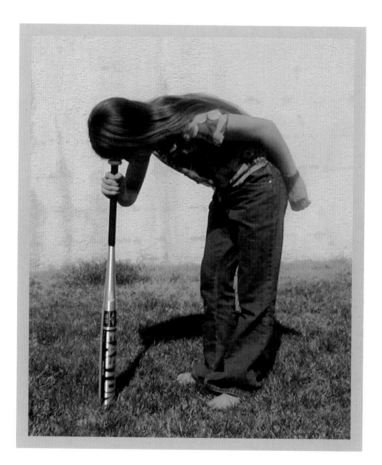

*Stand like the girl in this picture using a baseball bat.
Then make circles around the bat holding your head
fixed. This will really make the world appear to spin.*

A Delayed Reaction

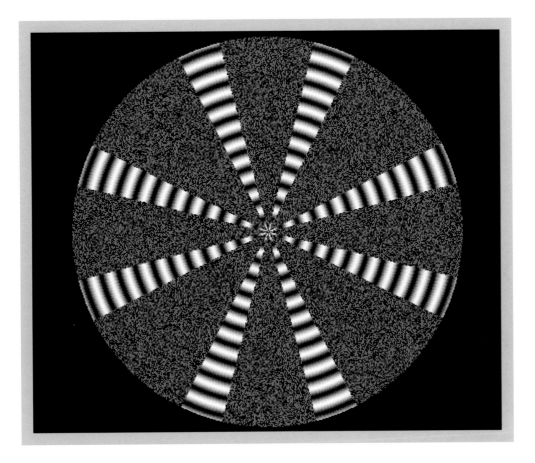

Move towards this image and then abruptly stop.

Vibration 2

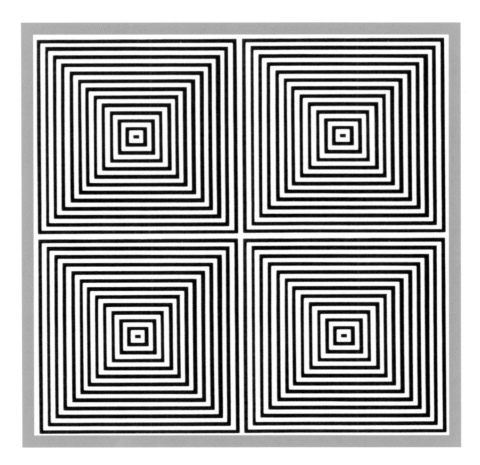

Move this square and it will appear to vibrate.

Pinna's Ouchi Variation

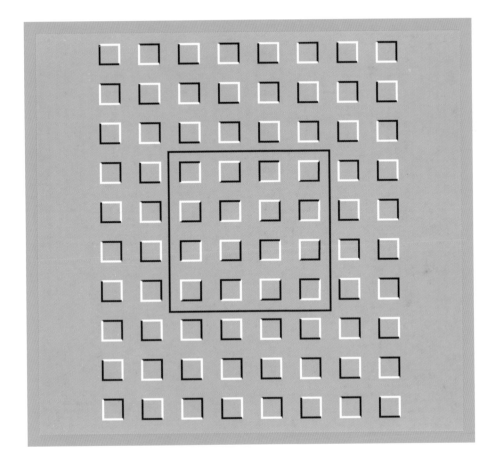

Move this image in an irregular manner.
What happens to the center squares?

Warp

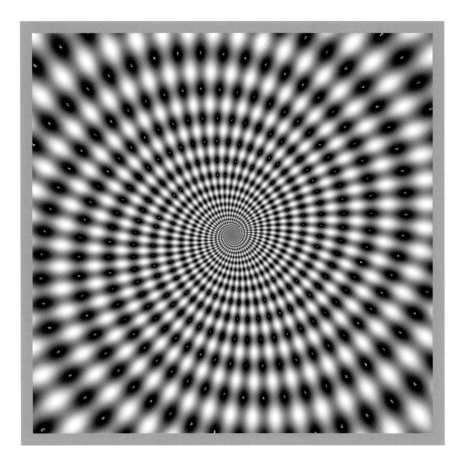

Move your head slowly towards and away from this image,
and it will appear to spin.

Ferry Boat

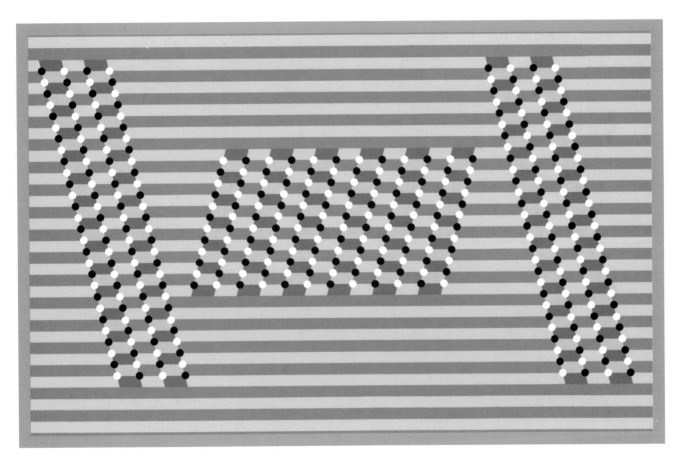

Stare at this image and the center section will appear to drift.

SUPER VISIONS: **Action Optical Illusions**

Waves

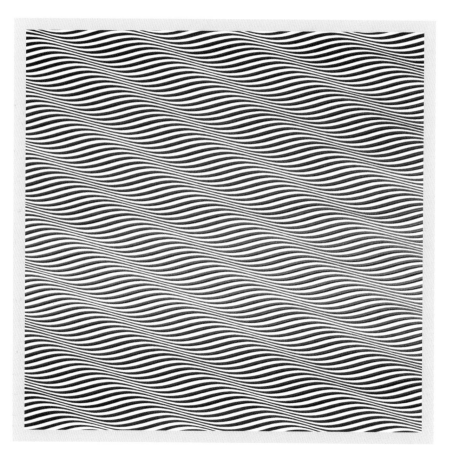

Move your eyes across this image and the waves will appear to ripple.

Tricky Tiles

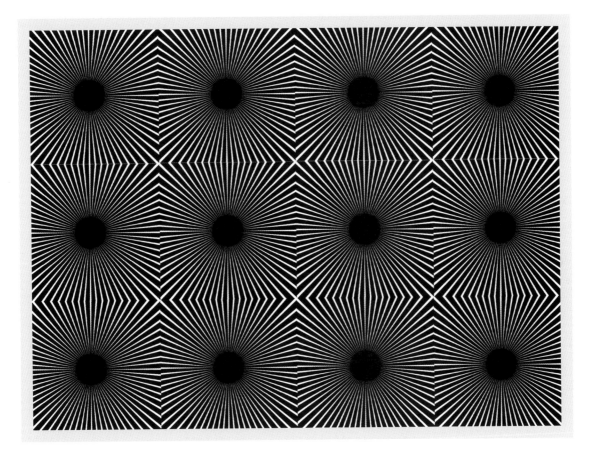

Move your eyes around this image and it will appear to vibrate.

Kitaoka's Vortex

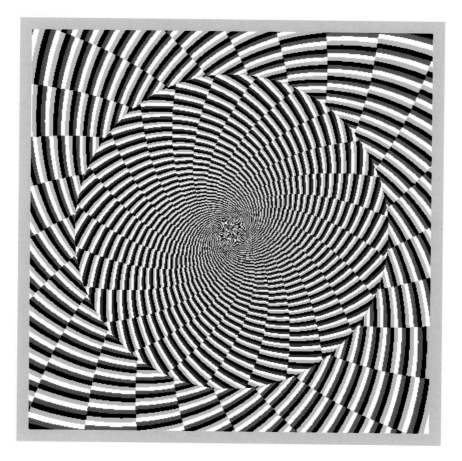

Move your head slowly towards and away from this image.

Driving Illusion

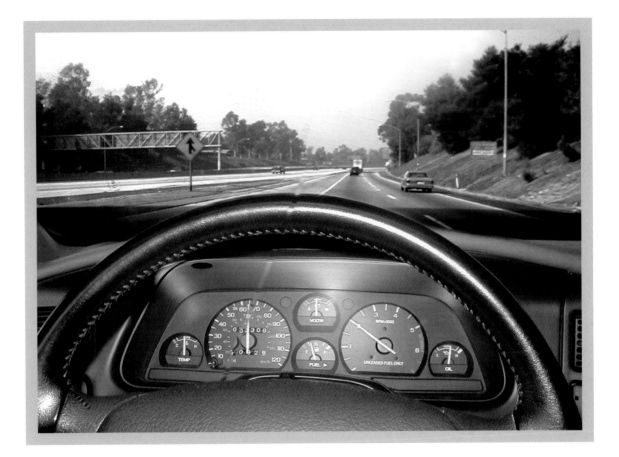

If you drive at a steady rate for any period of time, it will seem as if you are going slower and slower, which is part of the reason people get speeding tickets. They accelerate to get the initial sensation of going fast.

Heat Devil

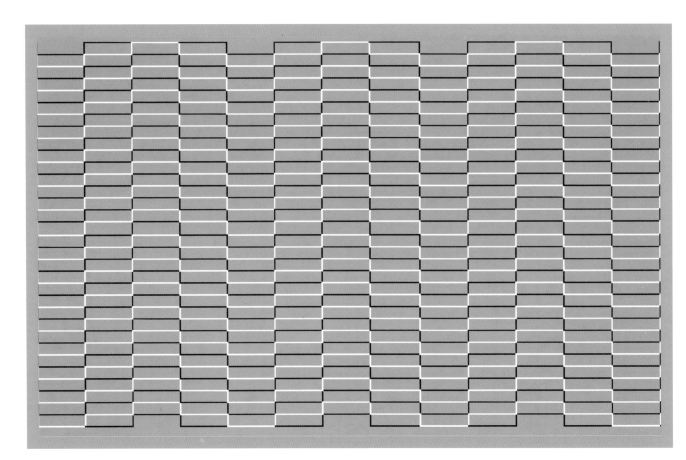

Move your eyes around this image and it will appear to pulsate.

Moving Scene Behind a Window

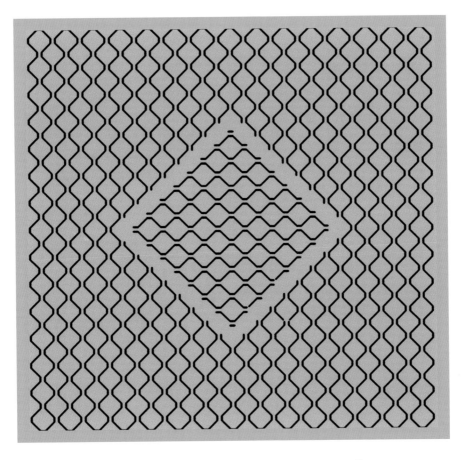

Slowly shake this image and the center section will separate.

Falls

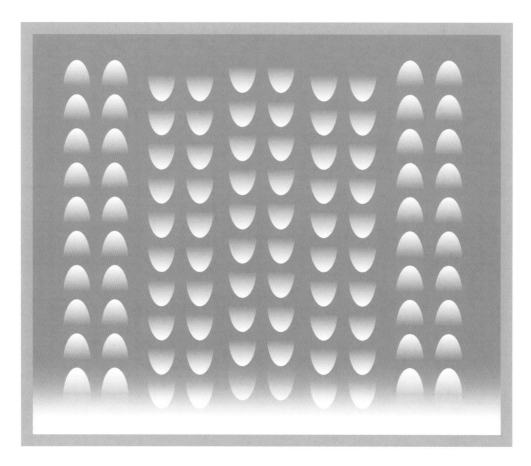

*Stare at this image and the middle section will move down
and the outer sections up.*

ILLUSIONS OF BRIGHTNESS & CONTRAST

With these illusions you will discover that your perception of brightness and contrast can depend on a variety of different factors, including the context. You will also find images that appear to twinkle and scintillate.

The Scintillating Grid Illusion 1

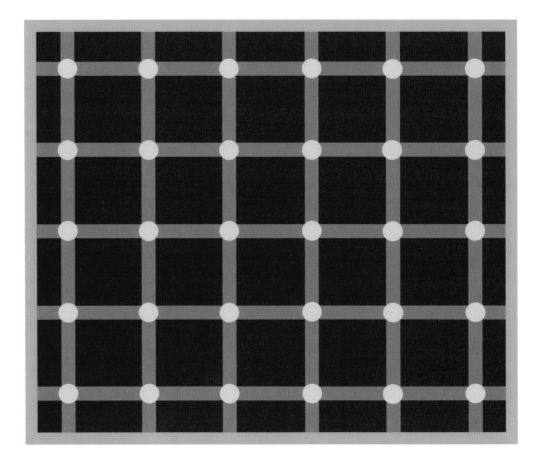

Move your eyes about this image and count the flashing dots at the intersections. Then count again. If you stare at any one dot it will disappear.

Purves and Lotto's Contrast Illusion

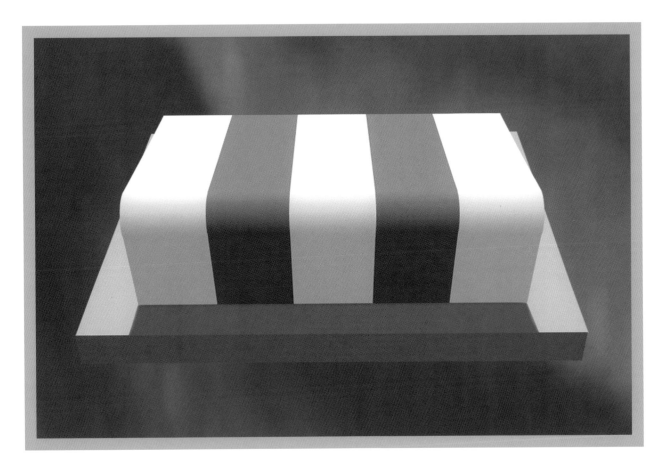

Look at the striped figure. It appears to be made of two gray stripes that lie in between three white stripes. However, the two gray stripes on the top of the figure are identical grays with the three white stripes on the front of the figure.

The Hermann Grid Illusion

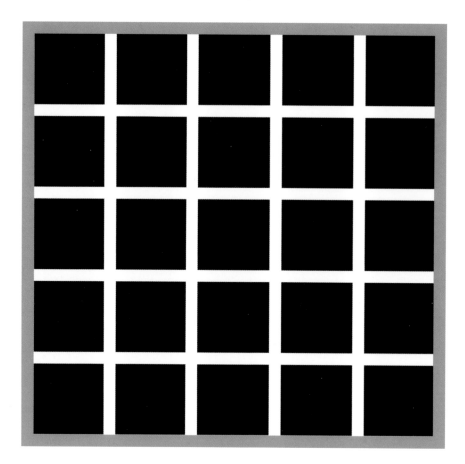

Do you see ghostly white dots at the intersection?
If you stare at any one dot it will disappear.

Assimilation Illusion

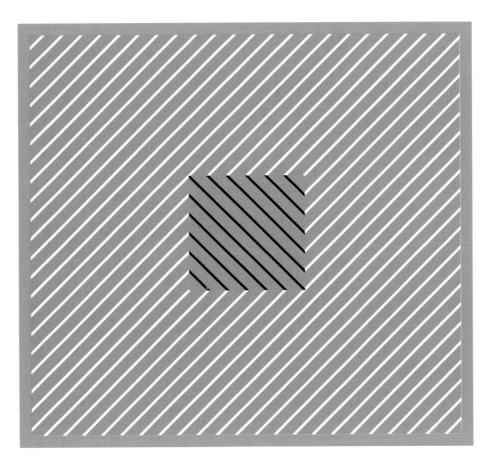

*The gray patch in the center appears darker than the surrounding gray,
even though the two areas are identical grays.*

Purves' & Lotto's Cornsweet Illusion

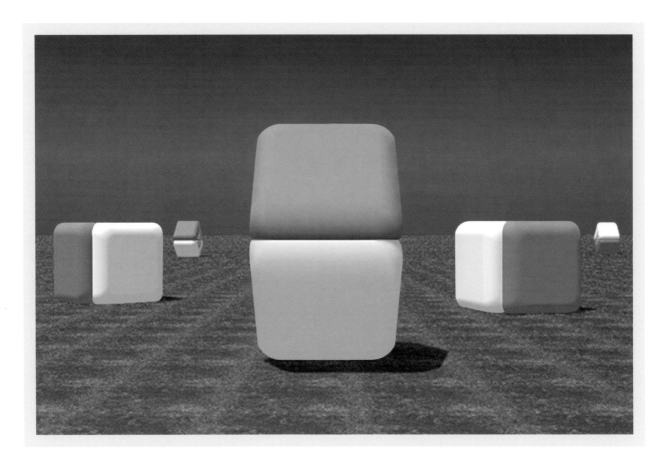

Do you perceive a dark block on top of a lighter block? Both blocks are identical shades of gray.
Put a pencil over the horizontal middle of the two blocks and you will see.

Craik-O'Brien–Cornsweet Illusion

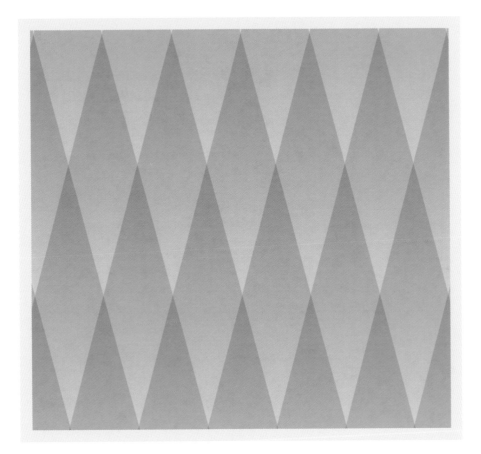

Look at each row of diamonds. Does each row appear darker than the row above it? All the diamonds are identical grays.

An Illusion Causing Another Illusion

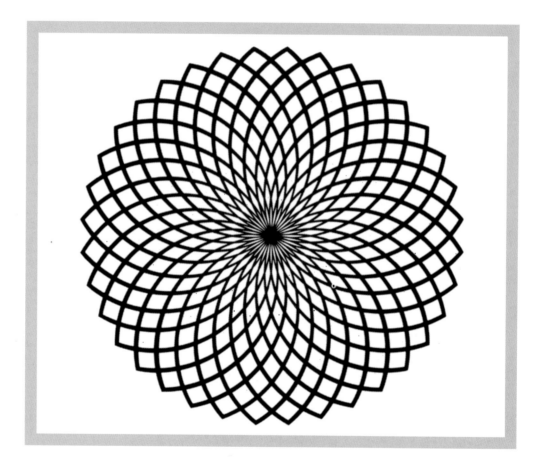

Do you perceive a series of concentric rings? This is an illusion caused by illusory dots at the intersections. Stare at any one dot and it will disappear.

Lattice

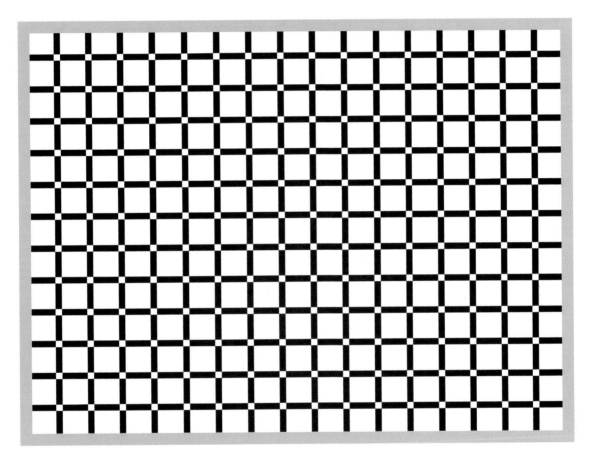

*Do the small white boxes at the intersections appear brighter
than the white background?*

Simultaneous Contrast Illusion

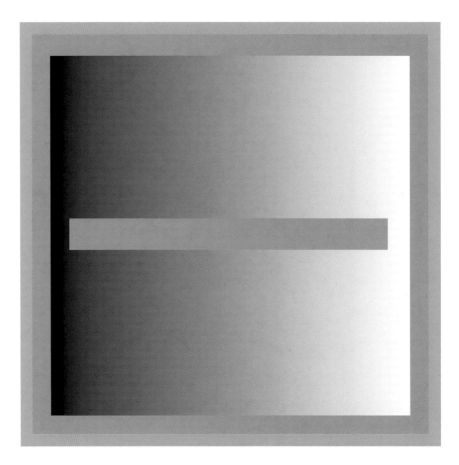

Is the horizontal bar the same value of gray throughout?
Cover everything but the bar to check.

White's Illusion

Are the two gray rectangles the same shade of gray?

Ghostly Dots in Blue

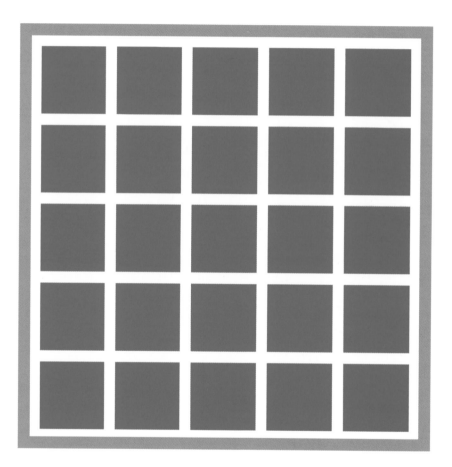

Do you perceive ghostly blue dots? Stare at any one of them and it will disappear.

Pinna's Scintillating Luster Illusion 1

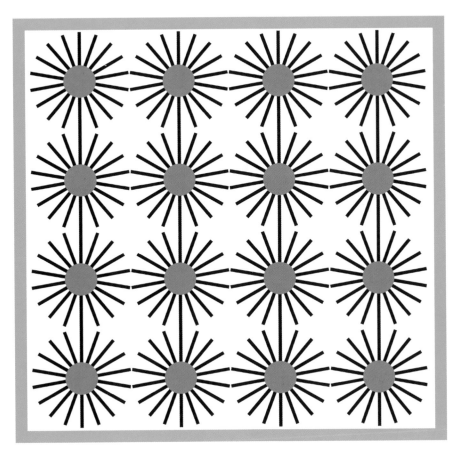

If you stare at this image it will appear to scintillate.

Todorovic's Dartboard Illusion

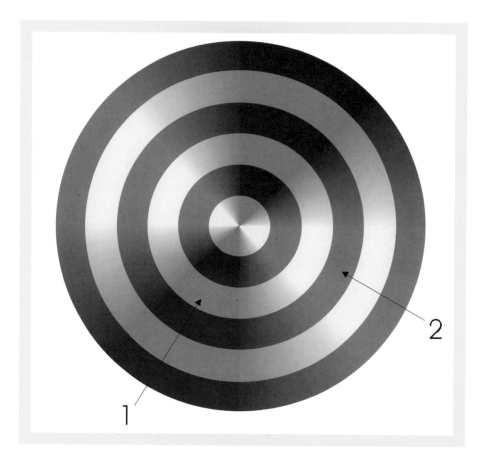

Do the "light" and "dark" regions, as indicated by the arrows, appear to be different values of gray? Believe it or not they are identical.

Todorovic's Gradient Chessboard Illusion

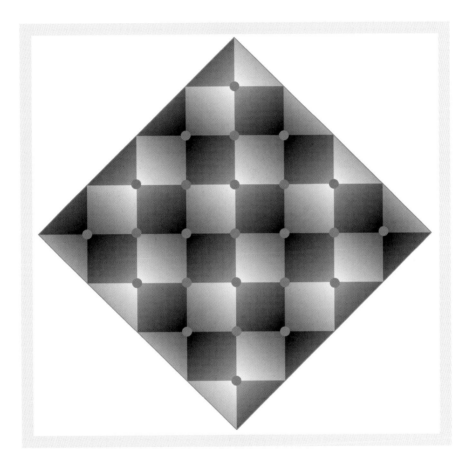

The dots at the intersections appear to be different values of gray,
but they are all identical.

Vasarely's Illusion

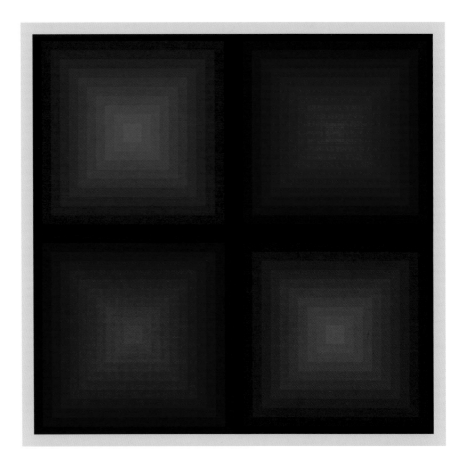

Do you perceive a bright diagonal cross within each of the squares?
The crosses are illusory.

Purves' Brightness Illusion

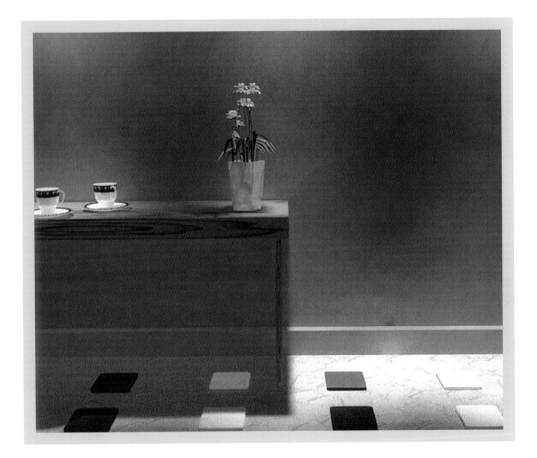

*The light check in the shadow is an identical shade of gray
to the dark check outside the shadow.*

Adelson's Checkered Shadow Illusion

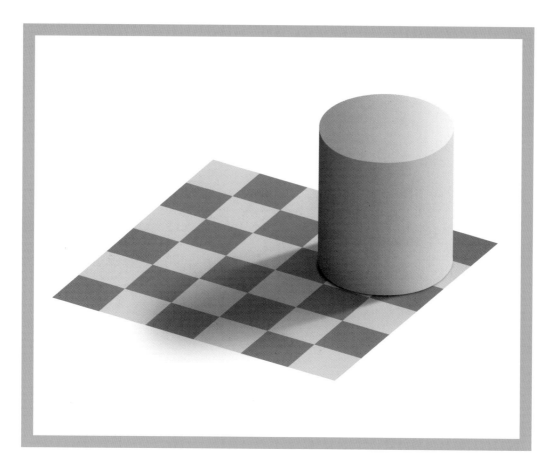

The light check within the shadow is the same value gray as the dark check outside the shadow. Cover everything but the two squares to check.

Ehrenstein Illusion

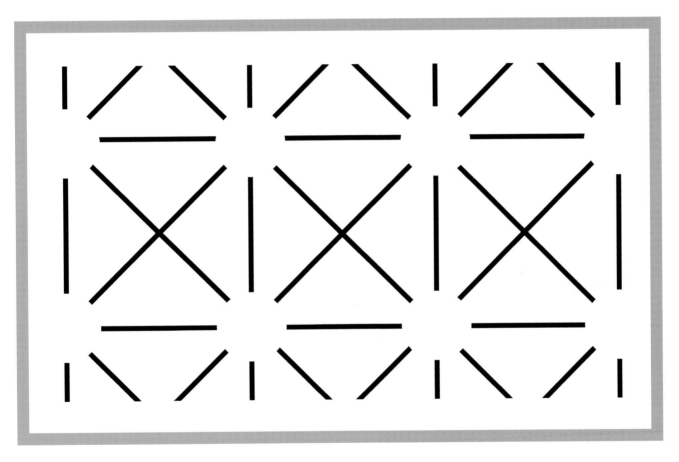

Do the white circles appear brighter than the wthite background?

The Scintillating Grid Illusion 2

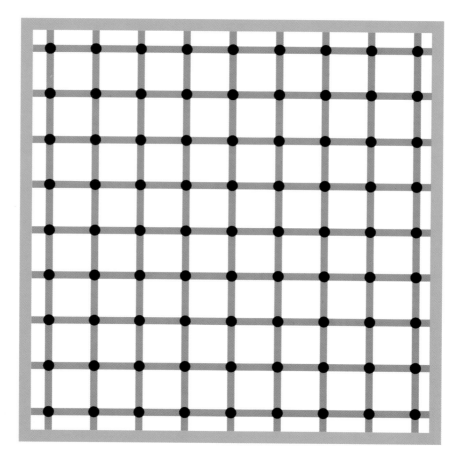

*As you move your eyes around this image you should see scintillating
dots at the intersections. If you stare at any one of them
it will disappear.*

Blanking

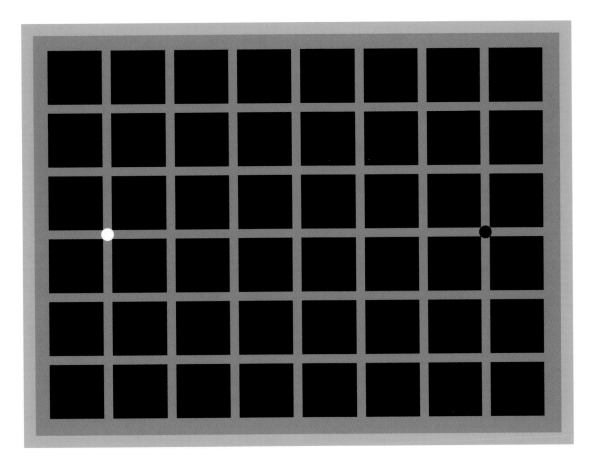

As you move your eyes around this image, illusory black dots abruptly appear or disappear at the intersections. See what happens when you stare at either the white or black fixation spot.

Filling-In Illusion

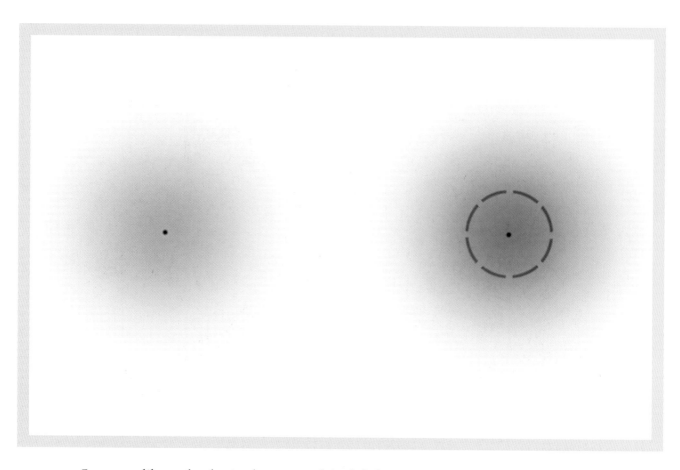

Stare steadily at the dot in the center of the left figure and the smudge will disappear. This will not happen with the figure on the right.

Checkers

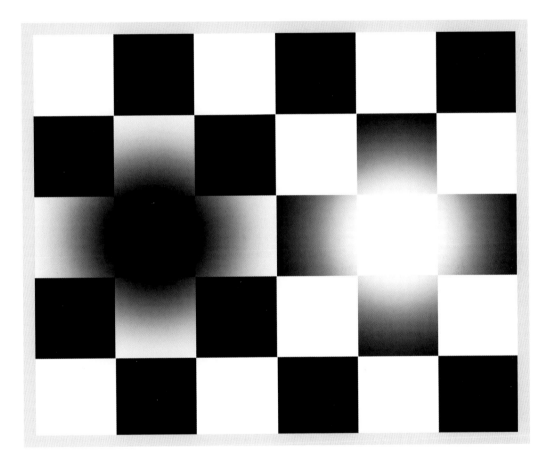

Does the white check within the fog appear brighter than the surrounding white checks? They are both identical whites.

Adelson's Snake Illusion

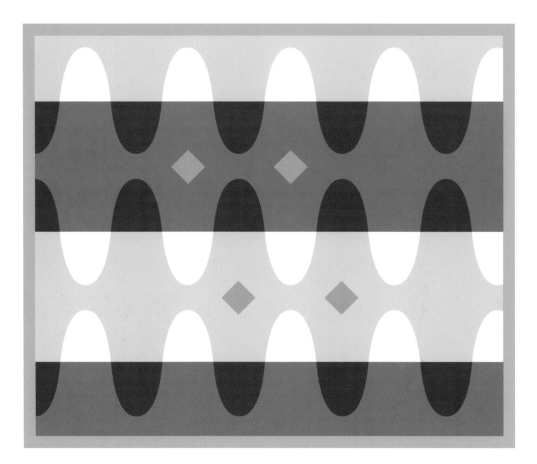

The four diamond shapes are identical grays! Check them by covering everything but the diamond shapes.

A Rotating Brightness Illusion

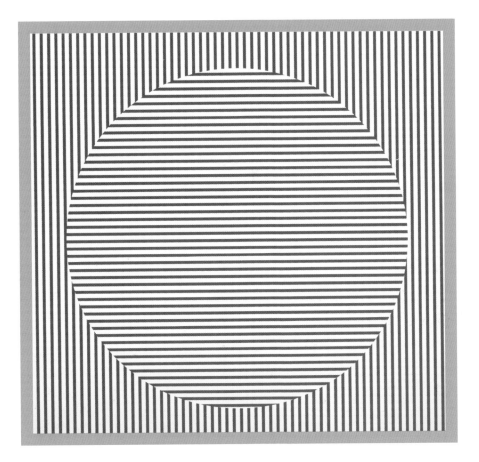

Rotate this figure and the brightness of the center section will appear to change.

Chevreul Illusion

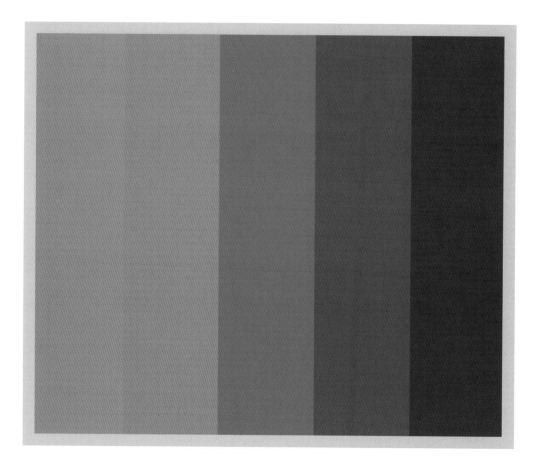

There are several adjacent rectangles progressively going from light to darker shades. Place a pencil over the border of any two rectangles, and the two adjacent rectangles will appear the same.

COLOR ILLUSIONS

You will find with these illusions that your perception of color can also be dramatically influenced by a scene's context. You will also find images, where you can perceive color, even though there is no color present.

Subjective Colors 1

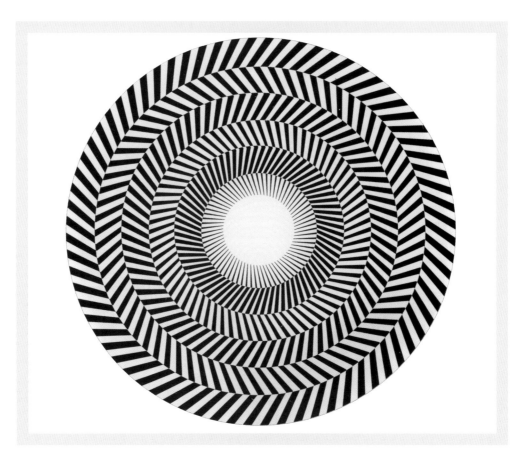

Slowly turn this image and you will see some faint colors.

Pinna's Watercolor Illusion

Do you perceive a faint colored hue within the borders?
Check, and you will see that it is white.

Colored Spiral Illusion

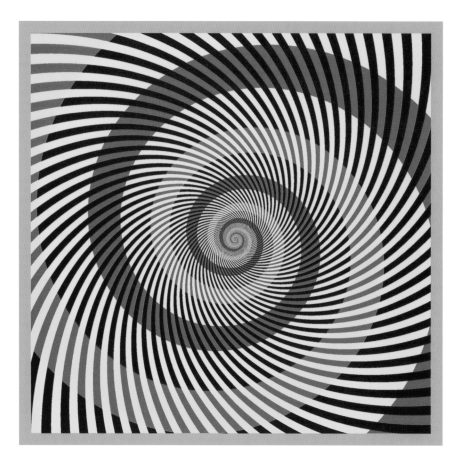

Believe it or not, the two spirals are identical in color!

Subjective Colors 2

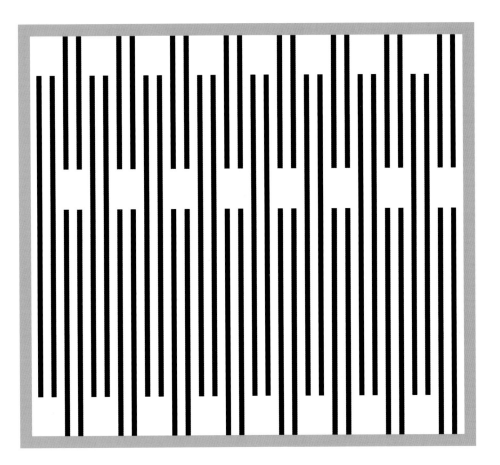

Move your eyes around this pattern and you will see some faint colors.

Benham's Disk

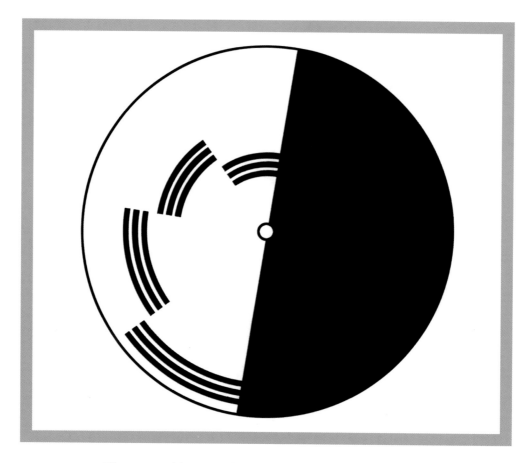

If you steadily spin this disk you will see faint colors.

Brucke Disk

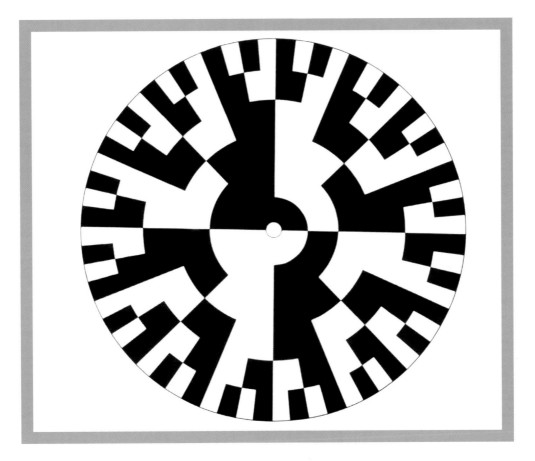

Steadily spin this disk and you will see colors.

Hermann Grid Variation

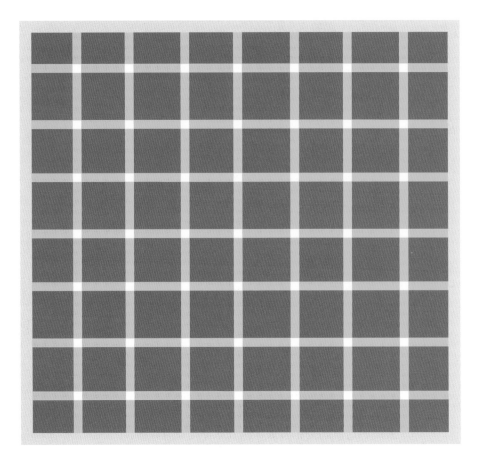

Move your eyes around this image, and you should see lilac scintillation.

Pinna's Scintillating Luster Illusion 2

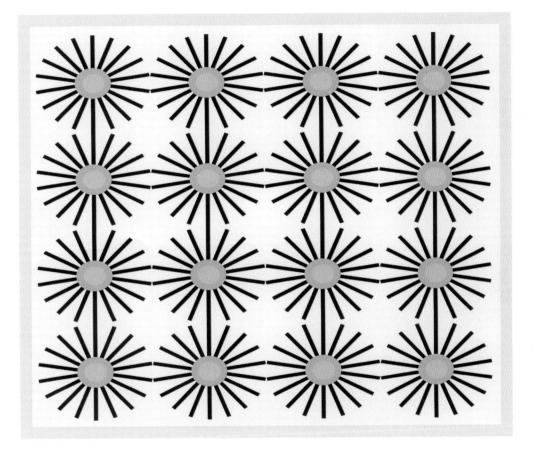

As you move your eyes around this image it will appear to scintillate in color.

Stroop Effect

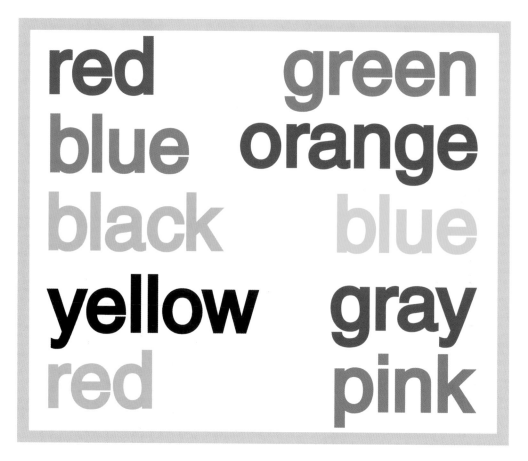

As fast as you can, say the color of the words, but do not READ the words. It is not as easy as you might think.

Neon Color Spreading 1

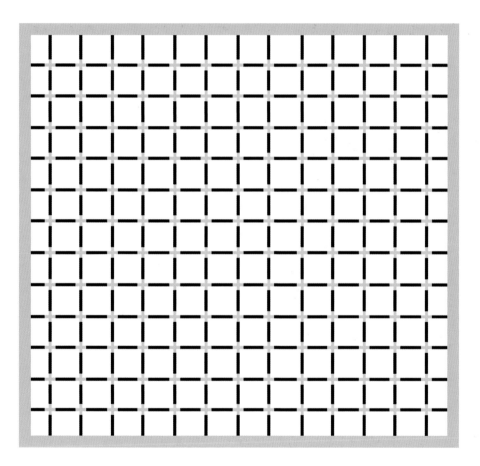

Do you see blue disks? There are only blue crosses.

Neon Color Spreading 2

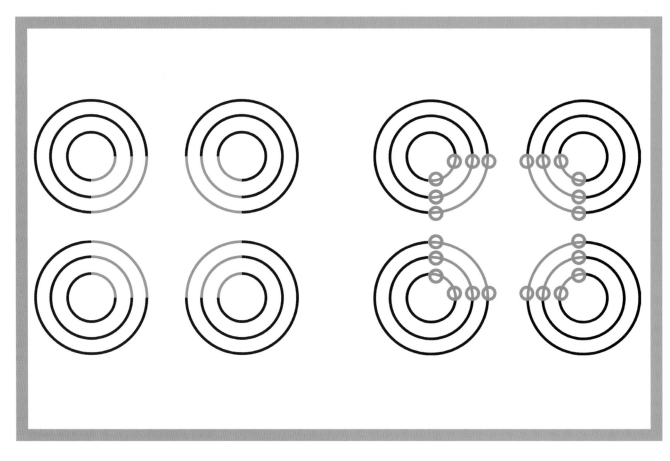

Do you perceive a faint bluish square? First of all, there is no square as there are no borders to define it. Secondly, there is no blue in the square. Only the small semicircles are blue in the left diagram. Check it through a peephole.

Color Contrast

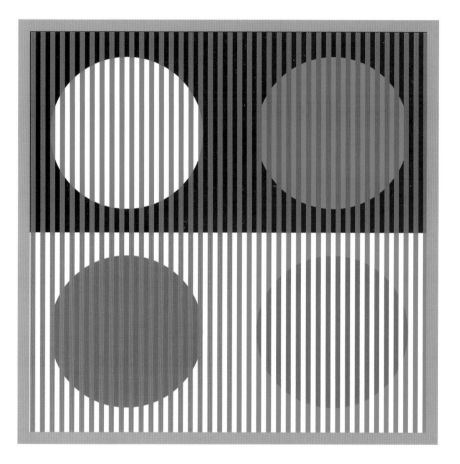

The green, red, and blue appear to be different shades,
when placed against a different surrounding color.

Rubik's Cube Color Illusion

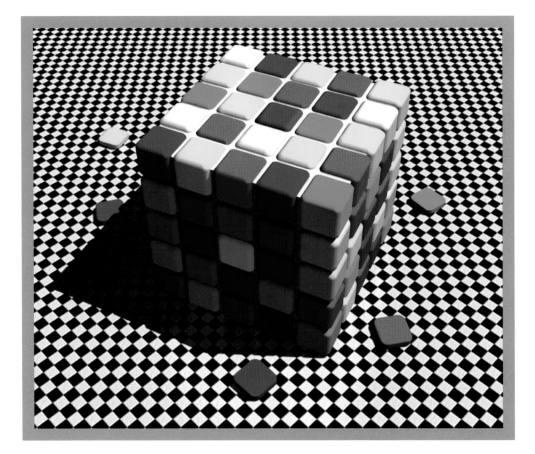

This is an absolutely amazing color illusion. The yellow check in the shadow is identical in color to the brown check on the top. Check it yourself by viewing the two squares through a small peephole, which covers the surrounding checks.

Fluttering Hearts

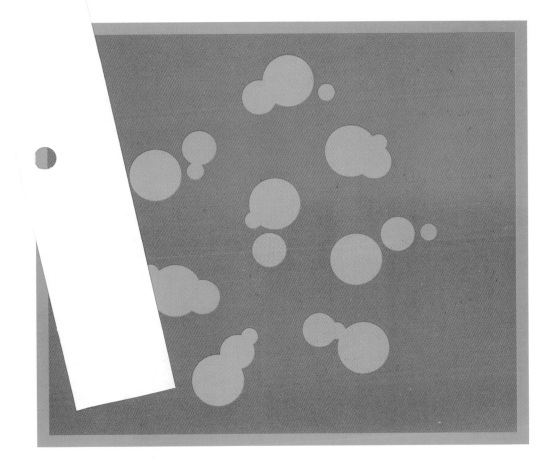

*Look at this image in very dim light. Shake the image
in small circular movements, which will make the blue spots
appear to leave a blue trail on the ground.*

Neon Color Spreading 3

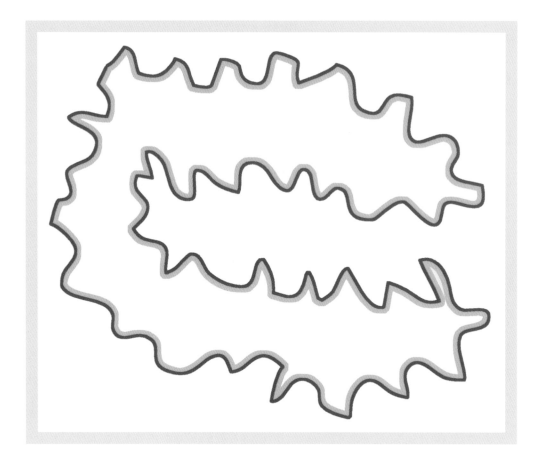

Do you perceive a faint color within the border? There is no color there.
Check it through a small peephole.

Color Assimulation

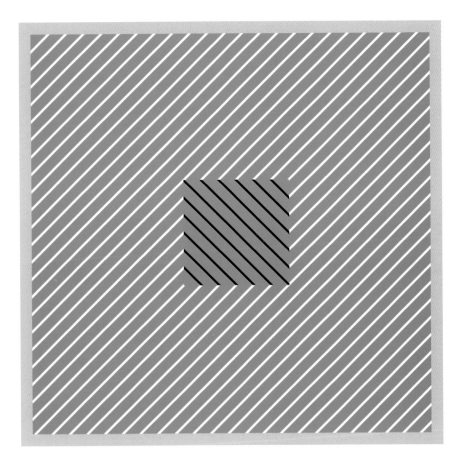

Does the middle green square appear darker than its surround?
They are both identical shades of green.

Bezold Effect 1

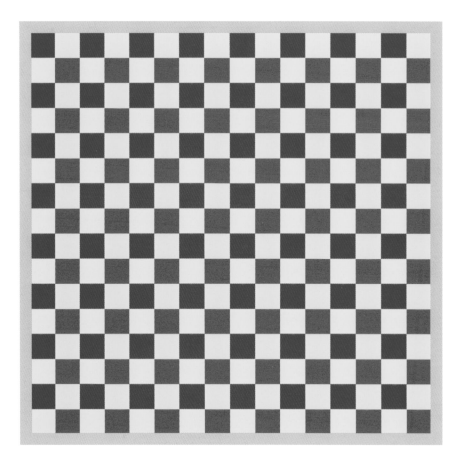

The red squares on this and on the adjacent page are both the same.

Bezold Effect 2

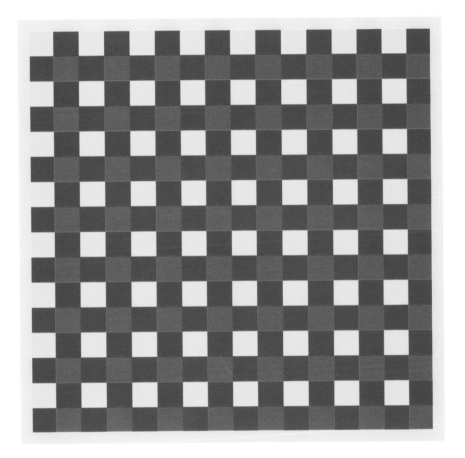

Compare the red squares with the red squares on the adjacent page.
Do they appear different?

Bezold Effect 3

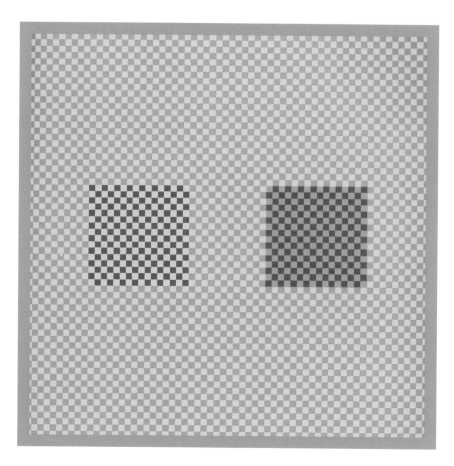

The red, blue, and yellow squares appear different depending on how they are surrounded.

Bamboos of Sagano

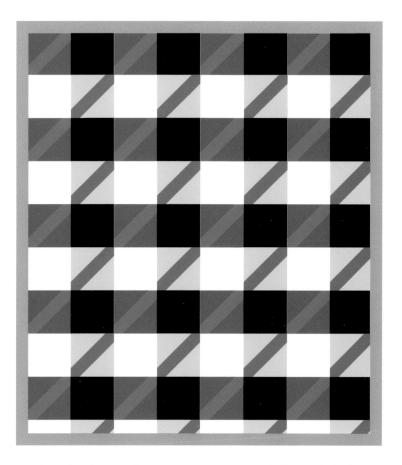

Do the diagonal green stripes appear light and dark?
They are identical throughout their length.

AFTERIMAGES & AFTEREFFECTS

Afterimages and aftereffects produce the perception of glowing images, even though there is no image present. It is similar to to what you get when you stare at a bright light source and then look away.

The Glowing Lightbulb

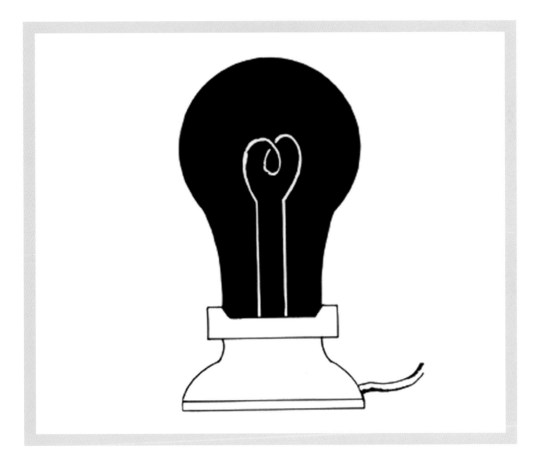

*Steadily stare at this image for at least 30 seconds without averting your gaze.
Then quickly look at a blank white sheet of paper
and you should see a glowing lightbulb.*

Glowing Ghost

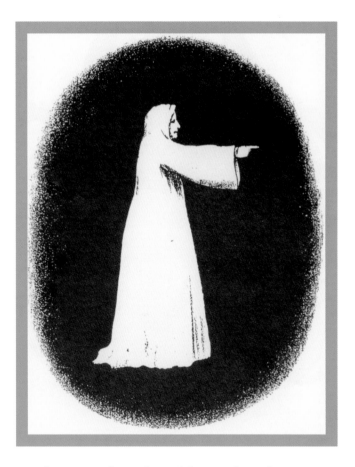

Steadily stare at this image for at least 30 seconds without averting your gaze.
Then quickly look at a blank white sheet of paper
and you should see a glowing ghost.

A Glowing Red Heart

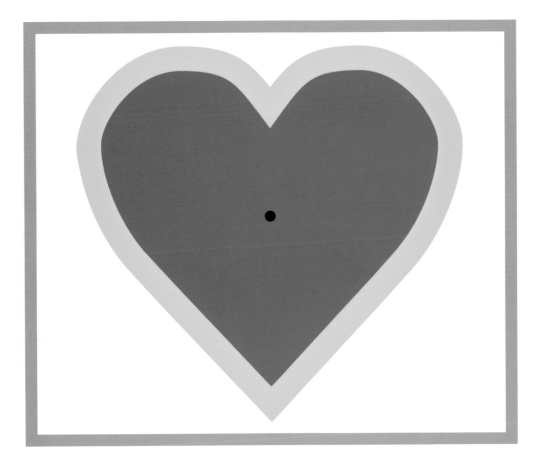

Steadily stare at this image for at least 30 seconds without averting your gaze.
Then quickly look at a blank white sheet of paper
and you should see a glowing heart in red!

SUPER VISIONS: **Action Optical Illusions**

A Glowing Flag

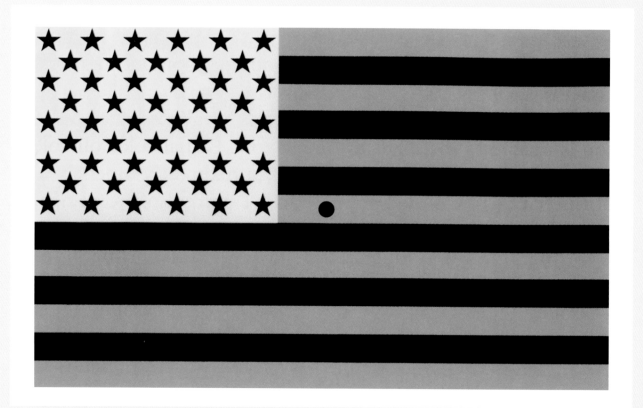

Steadily stare at this image for at least 30 seconds without averting your gaze.
Then quickly look at a blank white sheet of paper and you should see
a glowing flag in its proper colors.

Marilyn's Red Lips

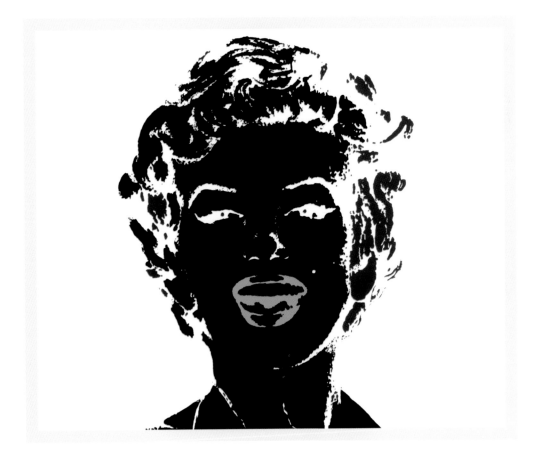

Steadily stare at this image for at least 30 seconds without averting your gaze. Then quickly look at a blank white sheet of paper and you should see Marilyn's lips glowing in red.

Glowing Angel

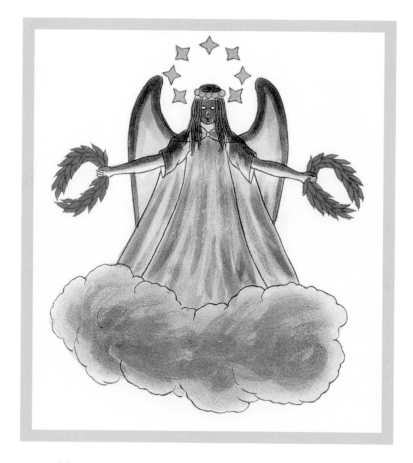

Steadily stare at this image for at least 30 seconds without averting your gaze. Then quickly look at a blank white sheet of paper and you should see a glowing angel.

Color After-Effect

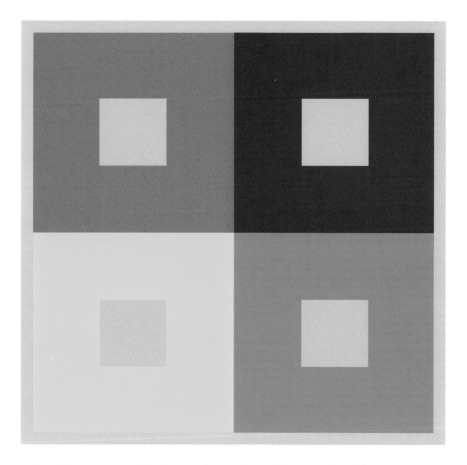

Steadily stare at this image for at least 30 seconds without averting your gaze. Then quickly look at a blank white sheet of paper and you should see all the squares in their complementary colors.

Tilt Aftereffect

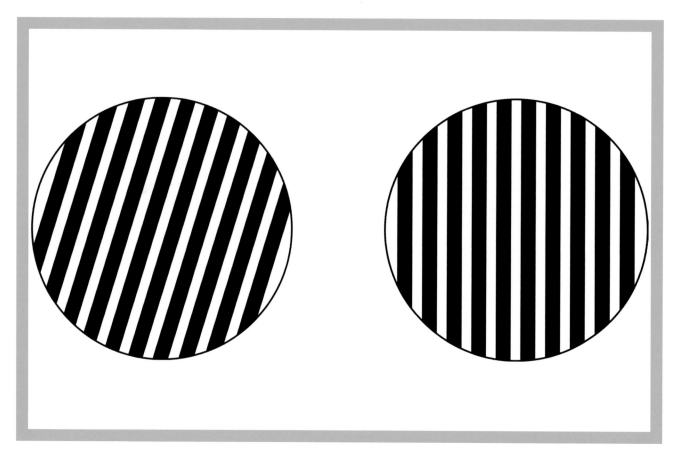

Stare steadily at the left diagram for at least two minutes without averting your gaze. Then quickly look at the right diagram. The lines will appear to tilt in the opposite direction to the ones on the left.

MacCollough Effect 1

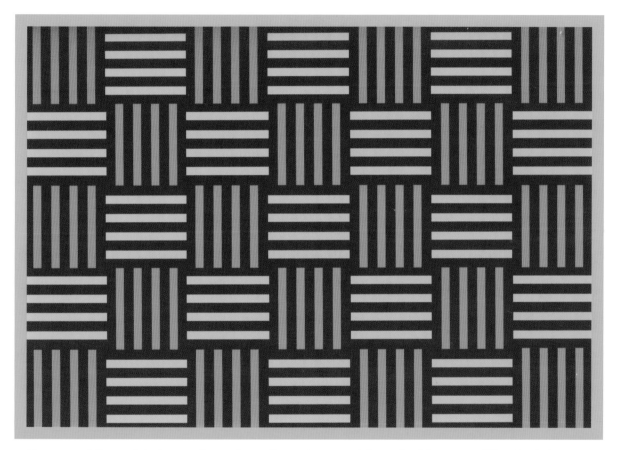

Stare steadily at this image for at least five minutes without looking away. You don't have to stare at it, just move your eyes over the image. Then look at the image on the next page and you will see faint complementary colors. If you stare at it long enough, you may find that horizontal and vertical contours in your environment may take on these illusory colors.

MacCollough Effect 2

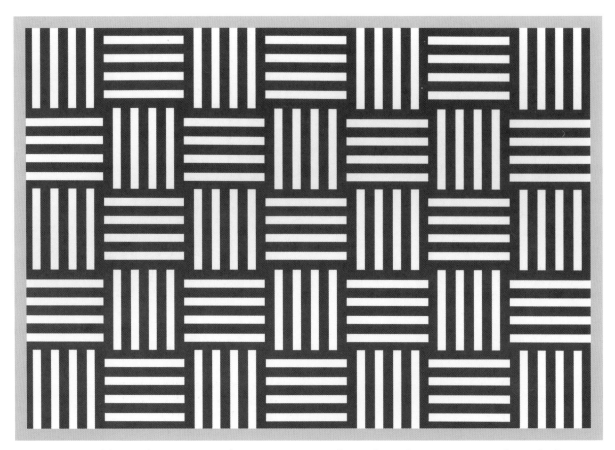

Stare steadily at the image on the previous page for at least five minutes without looking away. Then look at this image and you will see faint complementary colors. If you stare at it long enough, you may find that horizontal and vertical contours in your environment may take on these illusory colors.

INDEX

ABOUT THE AUTHOR

Al Seckel is the world's leading authority of visual and other types of sensory illusions, and has lectured extensively at the world's most prestigious universities. He has authored several award-winning books and collections of illusions, which explain the science underlying illusions and visual perception.

Please visit his website http://neuro.caltech.edu/~seckel for a listing of all of his books on illusions.